Prologue

This is a diagramatic book with figures that may help in understanding the world around us. As I believe anything that exists has to be visible or experiencible in some form or other. So, I tried to exhibit various mental, biological and physical phenomena through descriptive images and texts. I find it more convenient than long paragraphs which usually consumes more time. Many visual and spatial problems have been illustrated here to make our understanding of world and ourselves more clearer. Each diagram is an independent one and should be viewed uniquely. I will be glad if it is well understood with enjoyment.

- Manas Ranjan Murmu

Let's start our journey

Experience P

Experience Q

Is experience of P equals to experience of Q ?

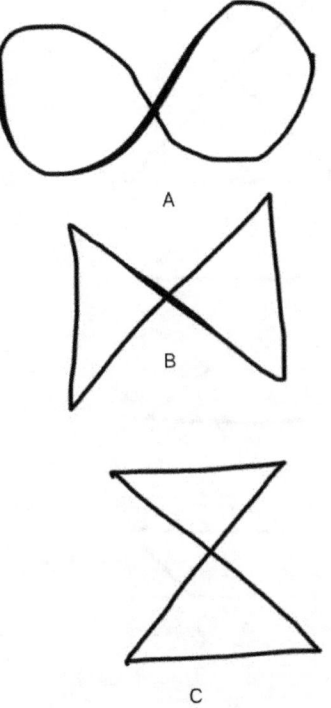

Are the figures (A,B and C) equal ?

How does the mind differentiate one from another cognitively when they are geometrically similar ?

Reducing the figure in halves

How one breaks into many ? How do we cognise quantity (numbers, symbols, concepts)
[One cannot break into many but one can display itself as many . And each display can be independently]

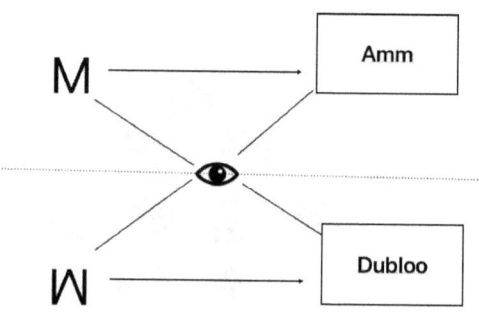

How can same figure be named and conceptualised differently?

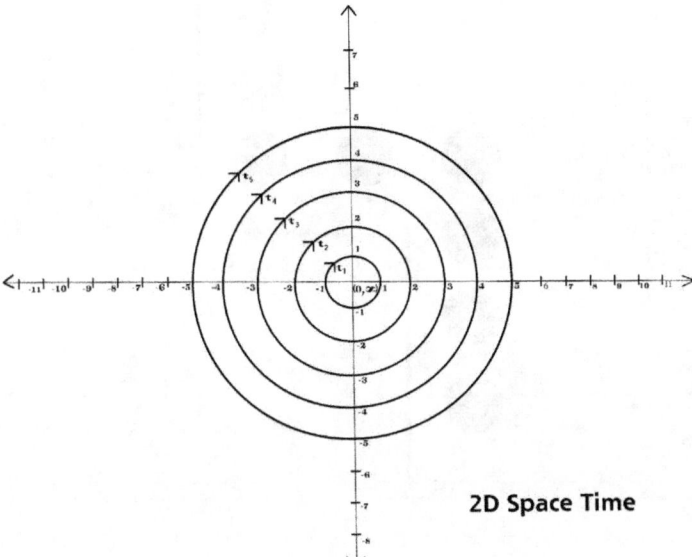

2D Space Time

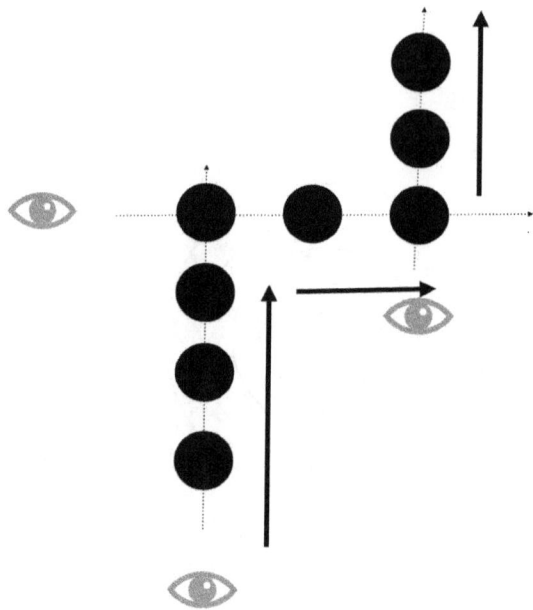

Spatial Memory

Perceiver (**P**) must be larger than what it is perceiving (*p*) in order to perceive it.

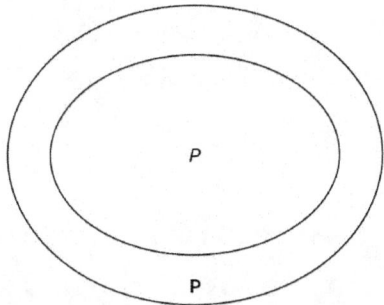

If **P** < *p* than it can perceive more than itself.

If **P** = *p* than it will perceive only how much it is only

If **P** > *p* than only it can perceive something smaller than itself

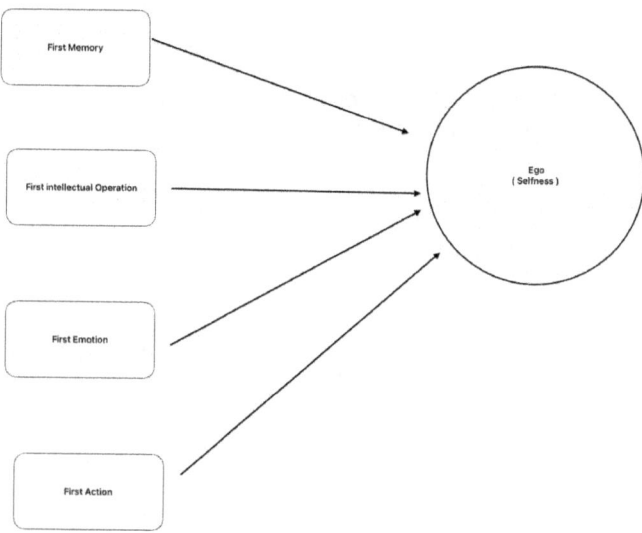

' It ' or ' I ' is the very First of All

Seeing

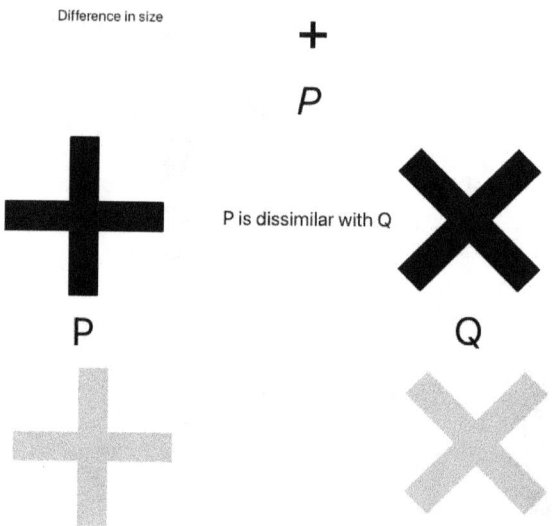

Are the two figures same ?

Experience of Sameness

Experience of difference

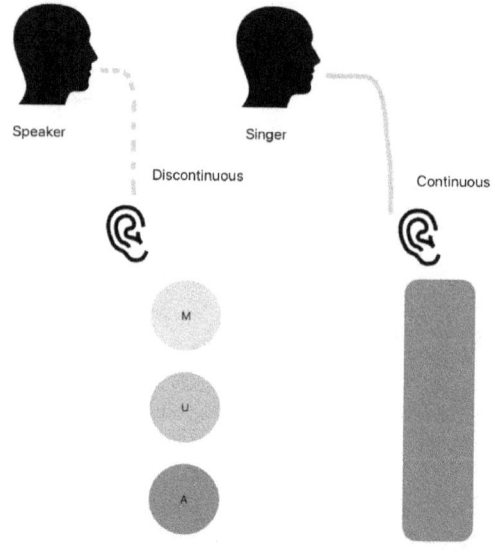

Music and Mind

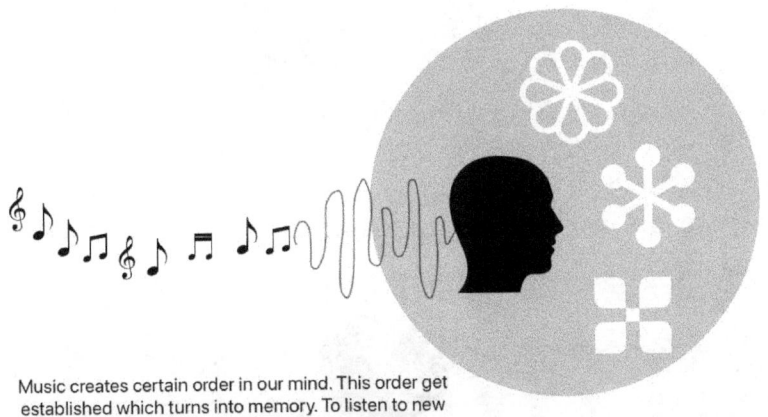

Music creates certain order in our mind. This order get established which turns into memory. To listen to new music is the establish a new pattern. There are multiple patterns in the mind which sometimes produce aesthetic experiences. These aesthetics looses their beauty when they are repeatedly experienced.

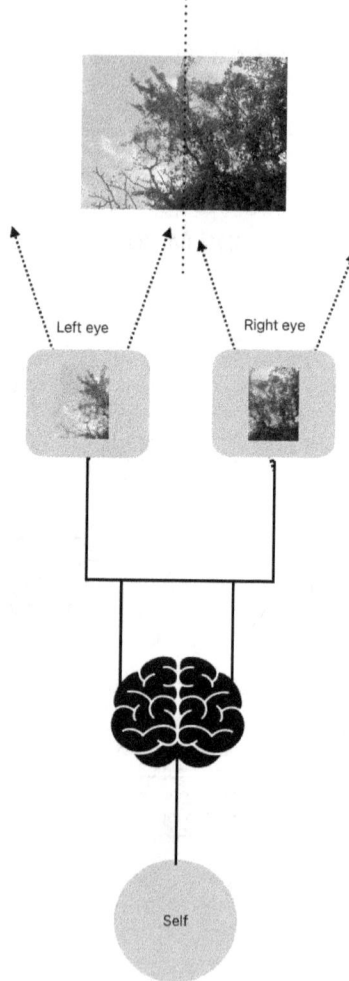

Formation of Self

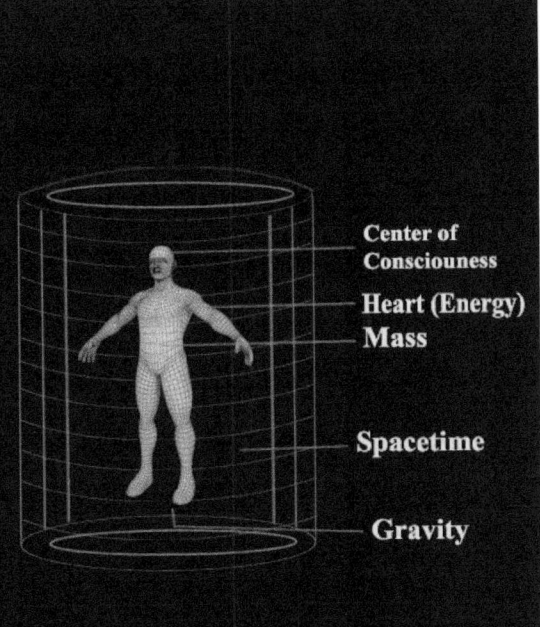

Conditions for Perception

- Shape Constancy
- Size Constancy
- Colour Constancy

Tracking the motion of fly

Experience of movement

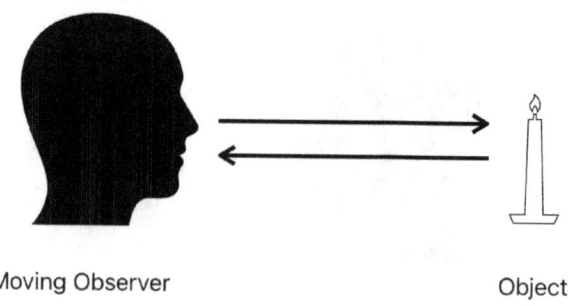

Moving Observer Object

Case 1 : Observer moving towards Object (e1)
Case 2: Object moving towards observer (e2)
e1= e2

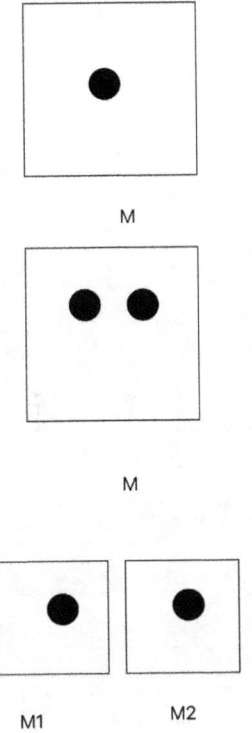

Division of Mind

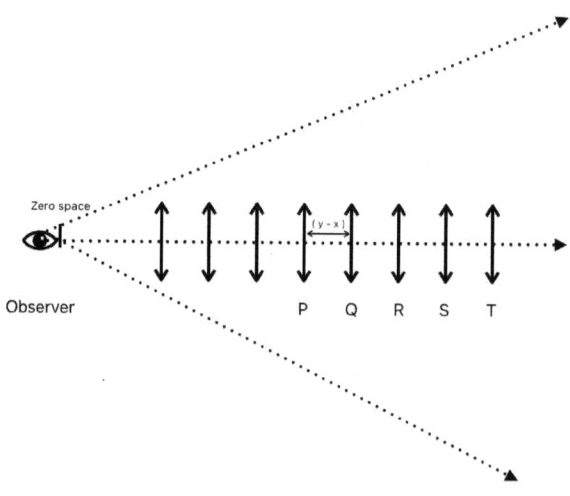

Spatial Perception I

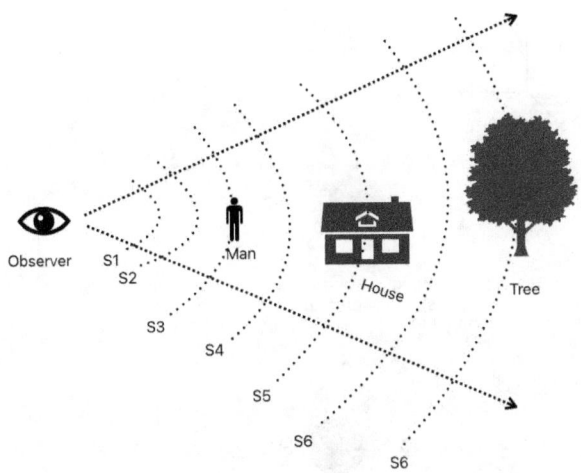

Spatial Perception II

Spatial perception III

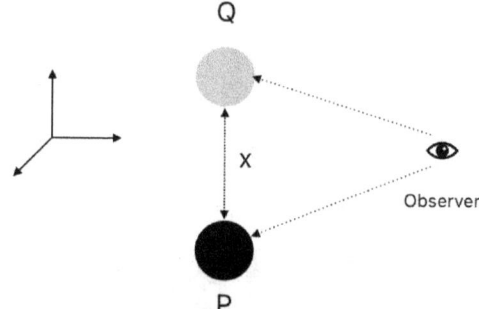

Case I : Two object (P and Q) perceived vertically in 3D space separated by distance x

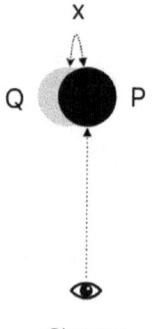

Case II : Objects (P and Q) perceived without direct experience of the distance x in 3D space

Spatial Perception IV

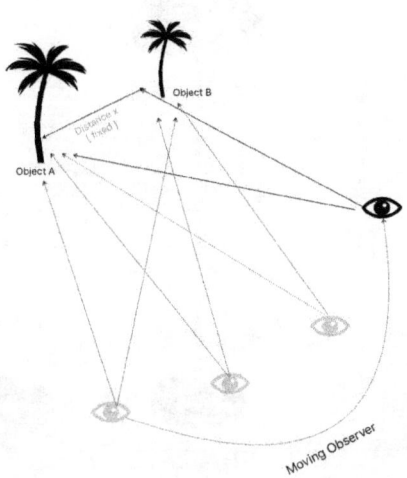

Fig : The observer perceives increase in distance between the objects (A and B) while moving spatially between the objects perceived.

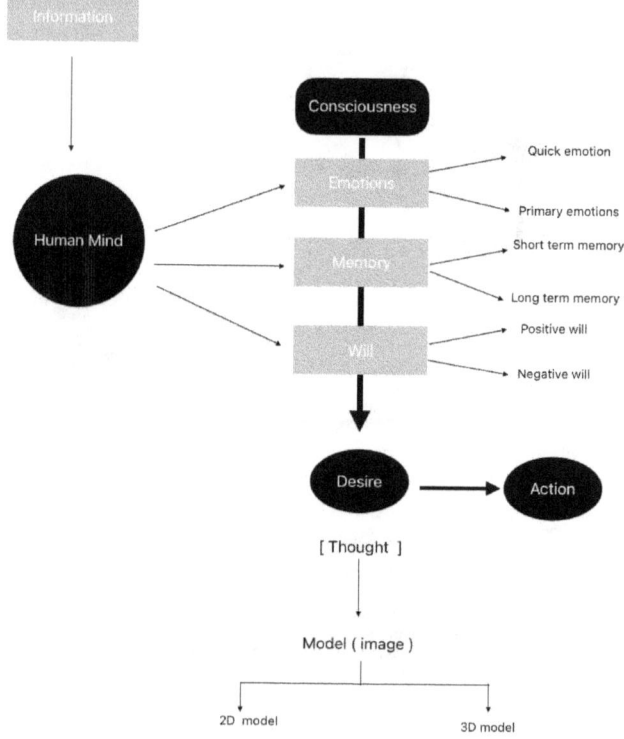

Cognitive Architecture I

When it comes to thinking, the mind seems to use perceptual experiences, espicially visual experiences to cognize and derive knowlege from it. Human thinking is being shaped by the way they have observed the world and we have tried a similar pattern to explain the universe and the mystrey of existence..There are three lines of order of human thinking viewed so far to explain 'what is'.

Ist line of Order

First line of order is the classical way of thinking in terms of origin, evolution and ending.

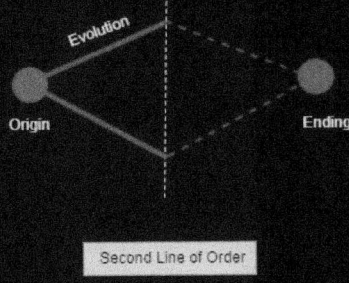

Second Line of Order

The second line of order is the view in terms of Existence and Non-Existence

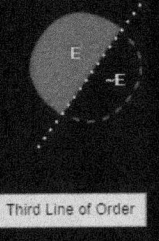

Third Line of Order

nes an underlying substratum (which need not have to be physical) where from everything appears

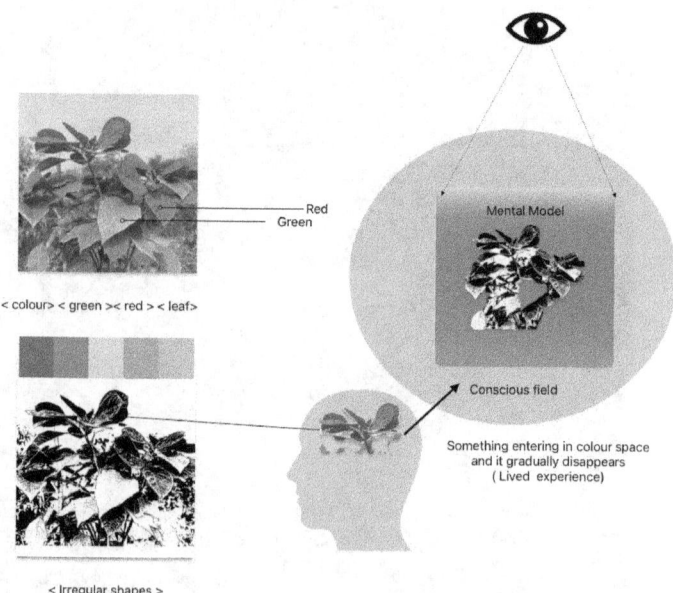

Fig: Formation of qualia in the consciousness

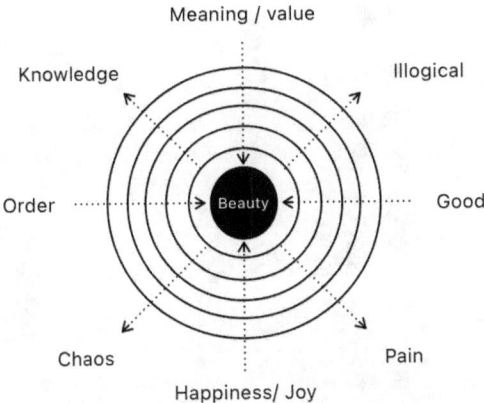

Fig: Spherical Coordinate system to measure the quality of beauty

Invisible point in Mind

How small can we mentally minimize an image ?

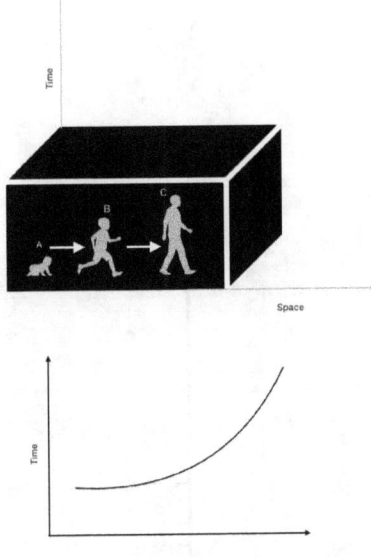

A– B– C (A=B=C)

$C = \epsilon / T$
$\epsilon = \text{consciousness} \times \text{Time}$

Human growth in Spacetime

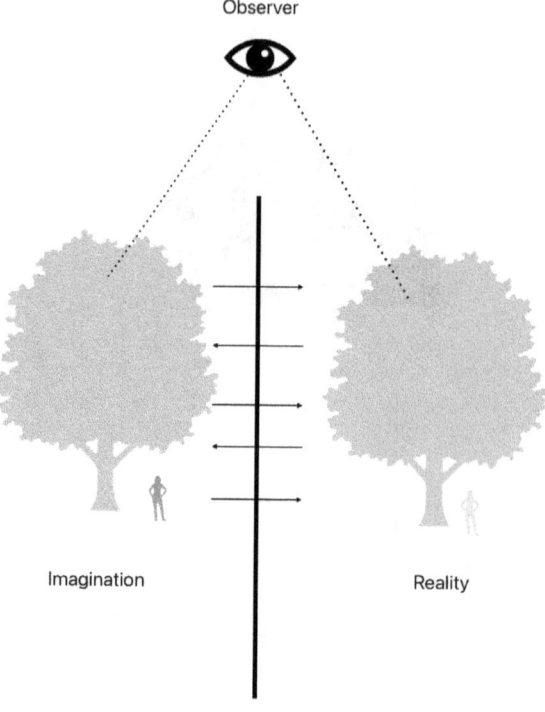

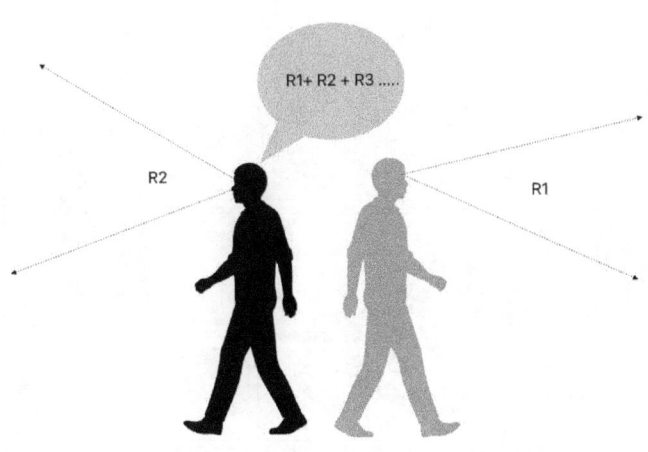

Creating the model of Reality

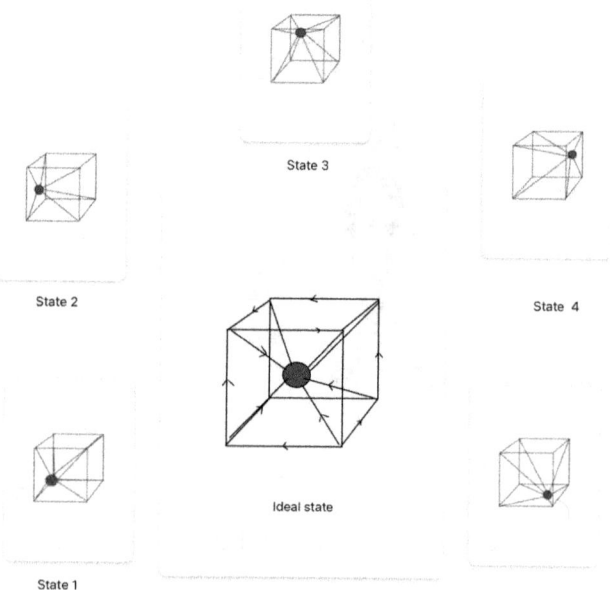

Mind is creating the dynamic model in our consciousness. When we move closer towards the objects we update our model into a new model and process goes on with addition of information.

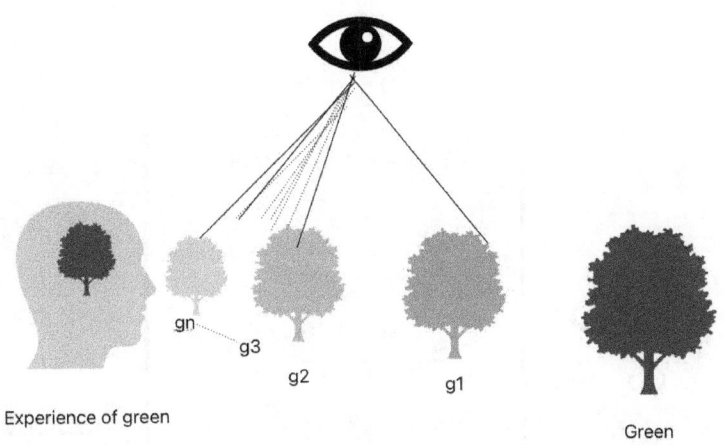

Experience of green Green

g1 can interact with g2
g2 with g3 and g1
g3 with g4 and g2 so. g3
can't interact with g1.

Levels of Perception

Synthesis of Beauty

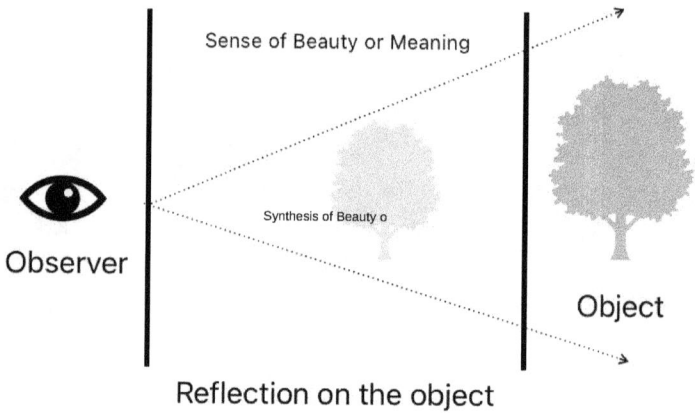

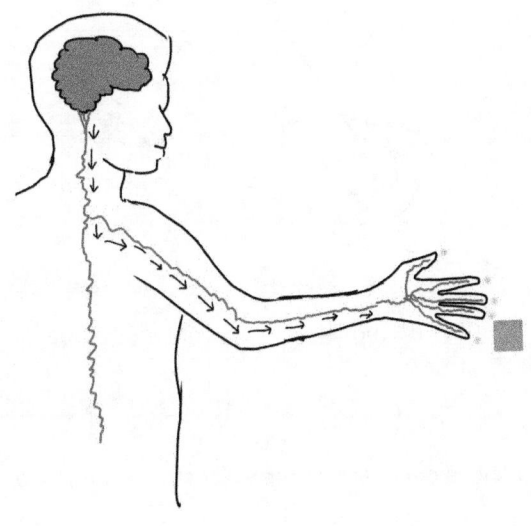

Expansion of Mind

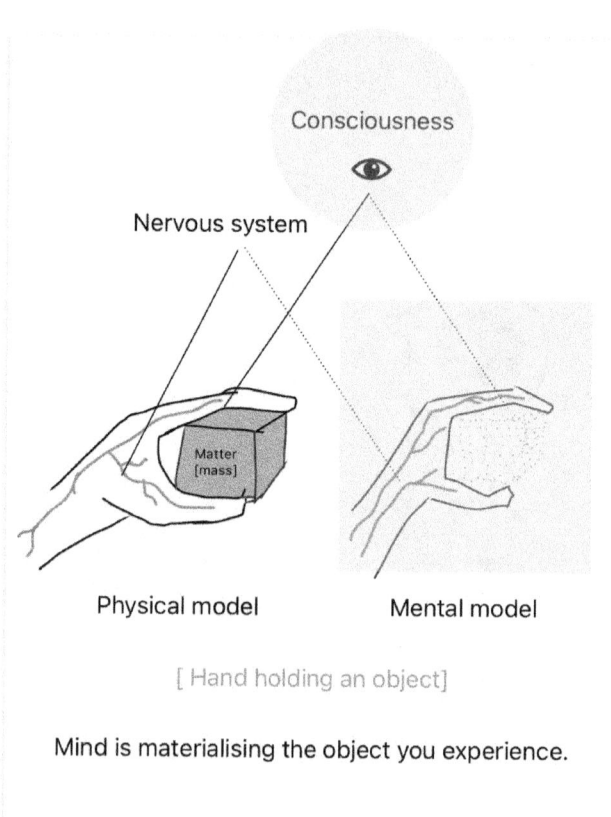

Materialisation

Mechanism of Action

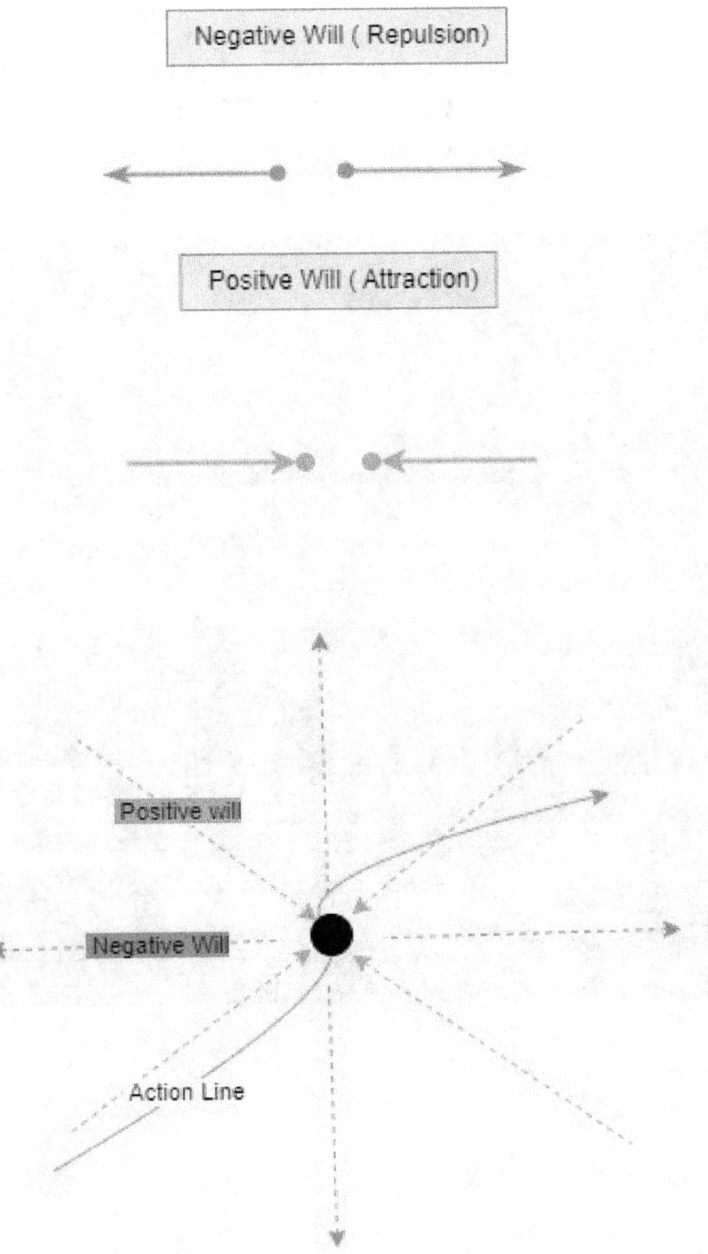

Actor and Action

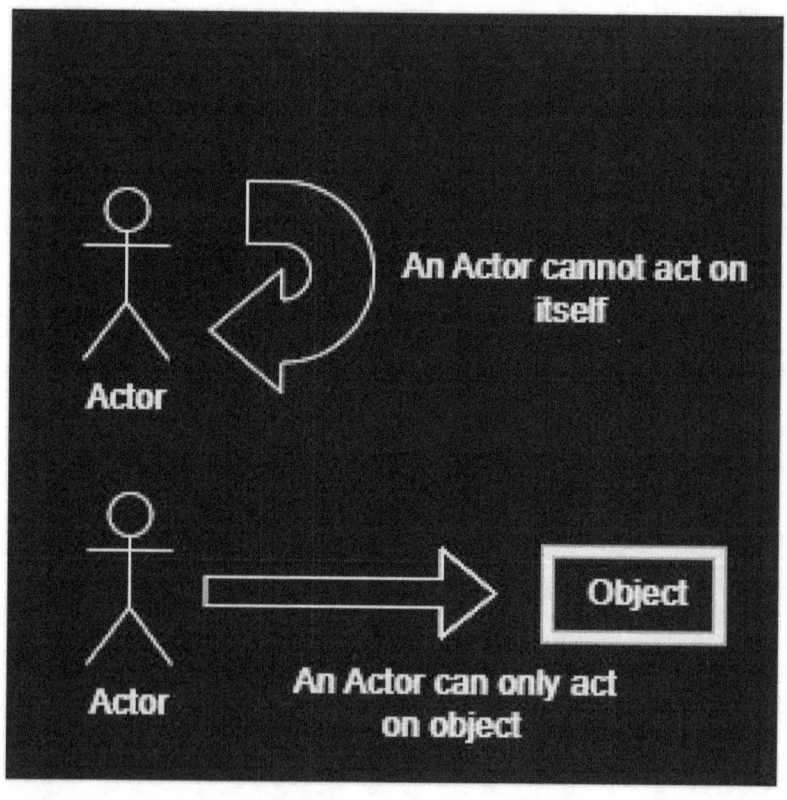

NO SUN

What would be the scale of measurement for direction if there would be no sun ?

Mind need a reference to start thinking. If there is no abstract number (1) there can never be any numbers at all . Similarly East is producing the West and North is producing South.

Your conception of direction stops there.

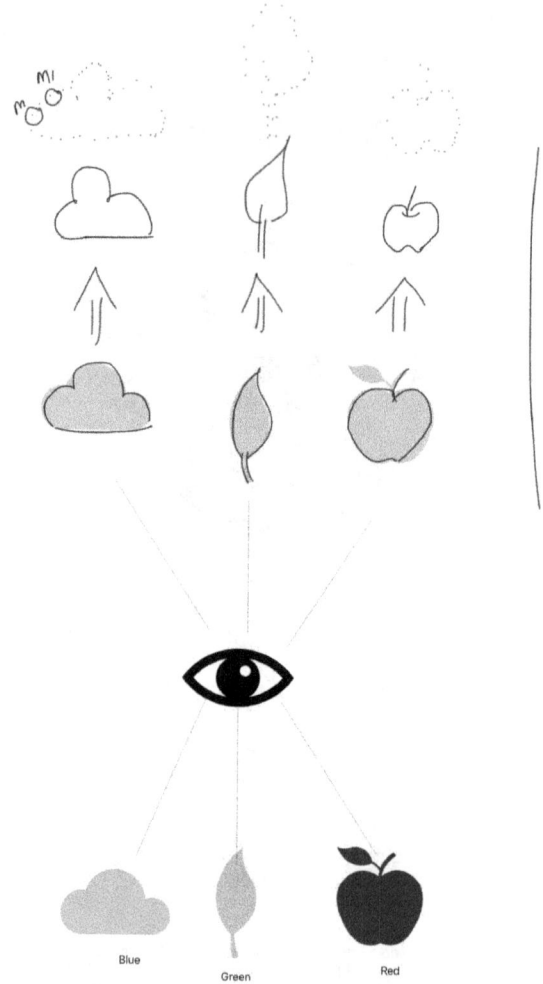

Extraction of Image

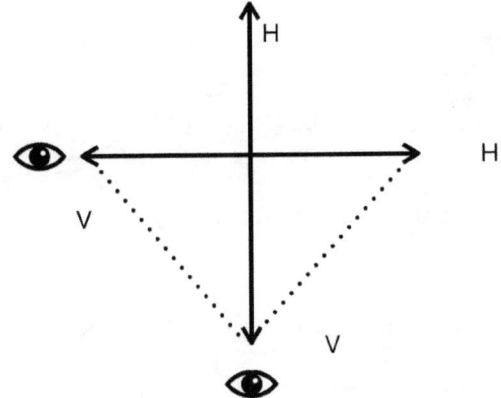

Relativity of Horizontal and vertical Orientation

Perceiving Concavity and Convexity

(A) Perceiving Concavity

(B) Perceiving Convexity

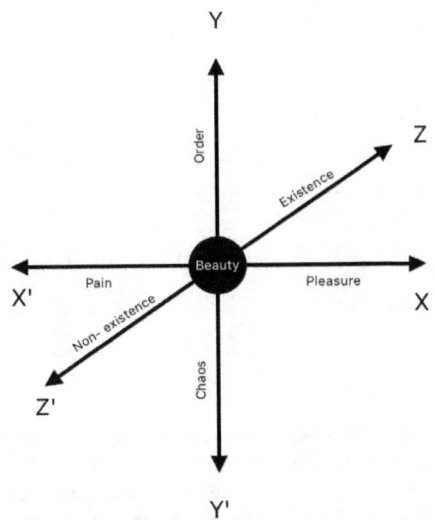

Beauty is the centre.

From which you measure any other emotion or experience

Object (with active mind) moving in Space

Remarks
- Space has no direction. Objects that moves in space havee directions.
- Observer doesn't change, only the observation changes.
- The spatial experience doesn't change with different orientation of the observer.
- There is no experience of moving space with respect to the observer.

Possible Cases
Case 1 : The observer is fixed but the space is moving.
Case 2: The space is stationary while the observer moves
Case 3: Both observer and space moves in accord to one another.
Case 4: Both space and observer are stationary

Motion

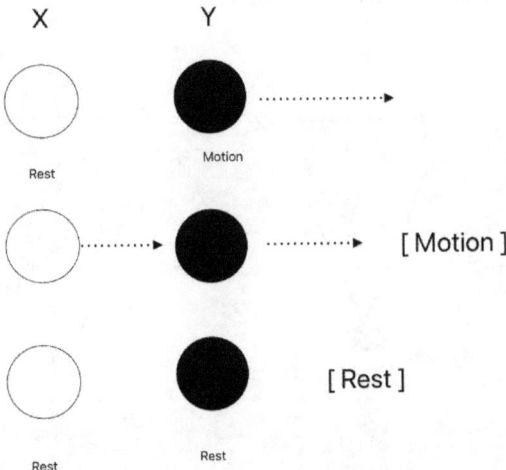

If the essence is at rest it's hard to imagine an active Universe

Transition of Experience

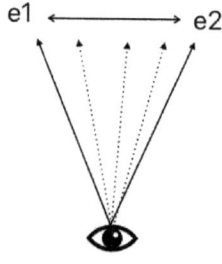

e1 (t1)
e2 (t2)

Transitory gap eg = e2t2 -e1t1

When we observe an object with a fixed colour then the mind is able to attain to that particular colour and be with it throughout the observation. This simple process becomes complicated when there is transition of experience. When we observe animals like octopus or chameleon changing their skin colours we perceive a transition in experience from one experience (e1) to another (e2) in time (t) .

Multi-colour light experience

Purple-Green-Blue - Yellow-Red

When we perceive colours from multi-colour light we measure the different experiences produced by it. There is no point of distinction between the colours we experience consecutively. It is not like one colour being entering the system and it get disappeared after sometime and then another colour enters. Rather these colours are blended in our experience.

Brief Explanation

The colour, shape and order are upheld by the experiencer to have the experience. When we look at any colour [e.g Green], there is only that colour in that particular experience. This colour is held by objects or surface having some mass, exist in spacetime and perceived by the observer. When we dissociate everything [including the space] in our mind, we are left with the beholder that provided the ground of the experience of that particular colour. The colour and the experience of that colour are indivisible. There is no colour outside that experiencer experiencing the [green] colour. In order to synthesise the colour and to experience it, the observer need to hold all the necessary condition for the experience. Similarly to experience another colour the observer has to dissociate the previous order to experience something new . It can't hold all the experience of every colours at one time, though we can perceive multiple colours but we can't direct our attention to all colours at once. Experiencing and becoming are same. When you experience something, you become that .

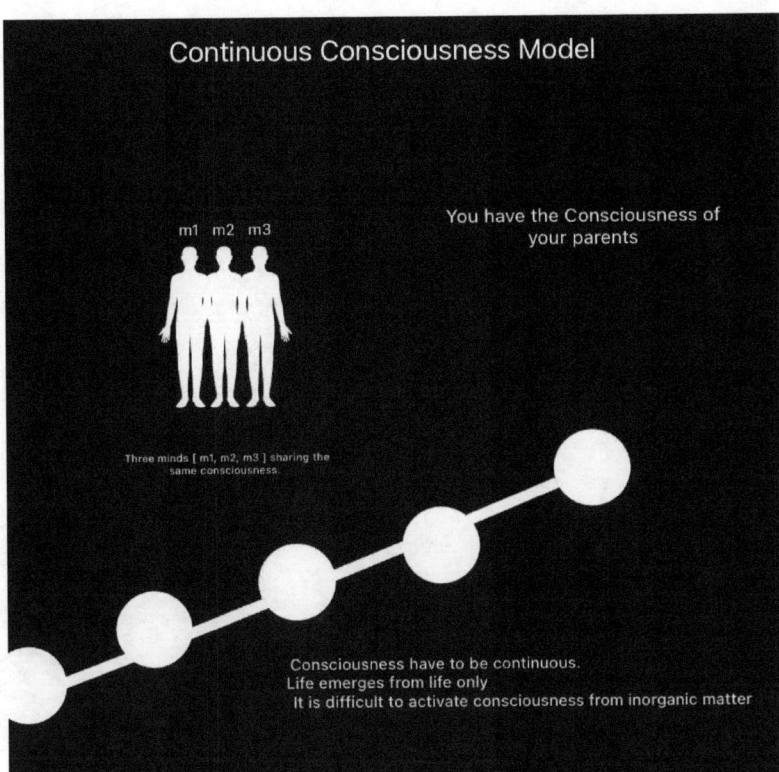

Life comes from pre-existing life.

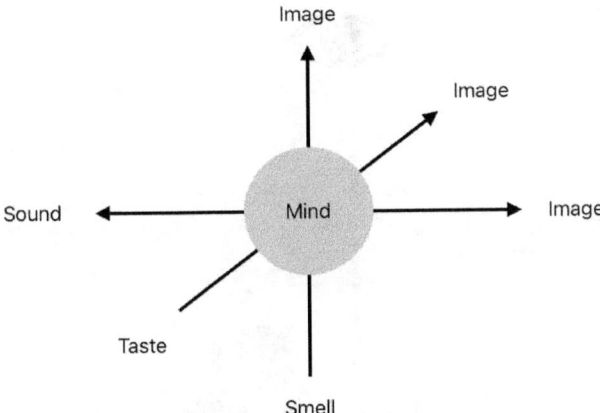

In the mind
- Sound are converted into images
- Smell are converted into image
- Touch are converted into images
- Taste are converted into images

But images can only be converted into sound. There fore we can only imagine sound but we cannot imagine smell , touch and taste.

Attention Gap

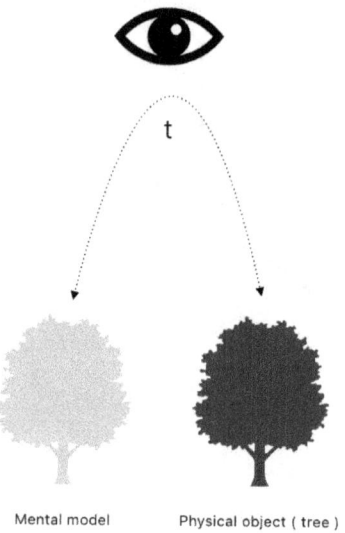

Consciousness takes time (t) to direct its attention from physical to the mental image. And to return from mental model to the physical object.

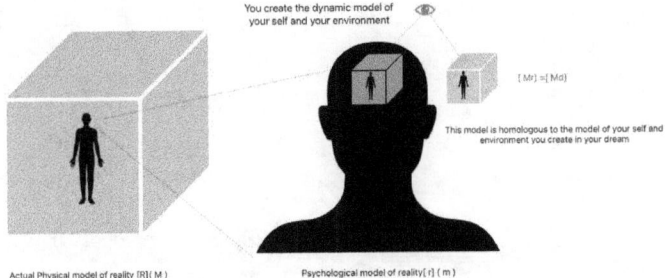

Mental Modelling

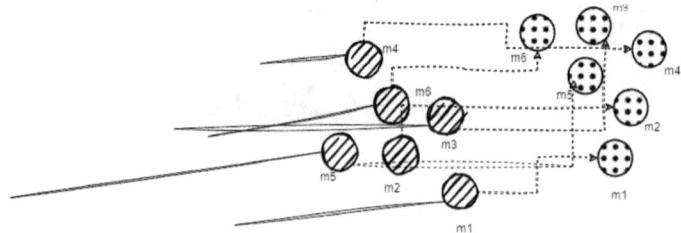

Memories of the memories

Meta- Reality

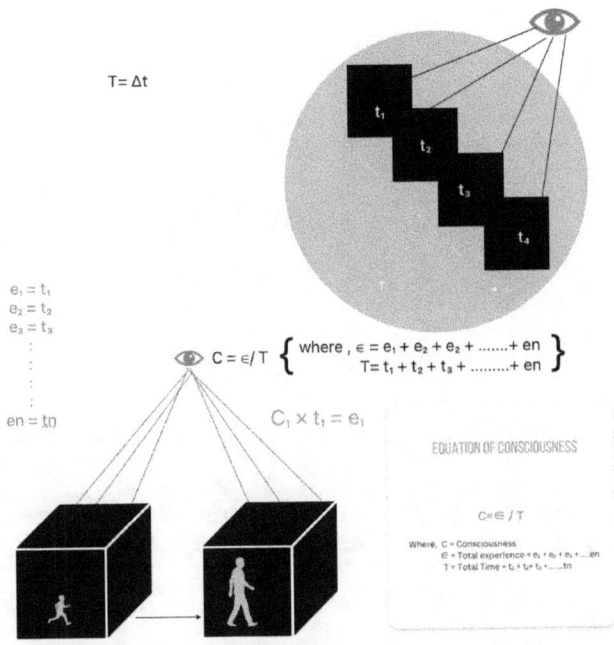

$T = \Delta t$

$e_1 = t_1$
$e_2 = t_2$
$e_3 = t_3$
\vdots
$e_n = t_n$

$C = \in / T \quad \left\{ \begin{array}{l} \text{where}, \in = e_1 + e_2 + e_2 + \ldots + e_n \\ T = t_1 + t_2 + t_3 + \ldots + e_n \end{array} \right\}$

$C_1 \times t_1 = e_1$

EQUATION OF CONSCIOUSNESS

$C = \in / T$

Where, C = Consciousness
\in = Total experience = $e_1 + e_2 + e_3 + \ldots e_n$
T = Total Time = $t_1 + t_2 + t_3 + \ldots t_n$

$R_1 = [\, S_1(x, y, z) T_1 \times M_1 \times E_1 / C_1 \,] \qquad R_2 = [\, S_2(x, y, z) \times T_2 \times M_2 \times E_2 / C_2 \,]$

Δt = Pschological time difference = $< t_2 - t_1 >$

$e_1 = < t_2 - t_1 >$
$e_2 = < t_3 - t_2 >$

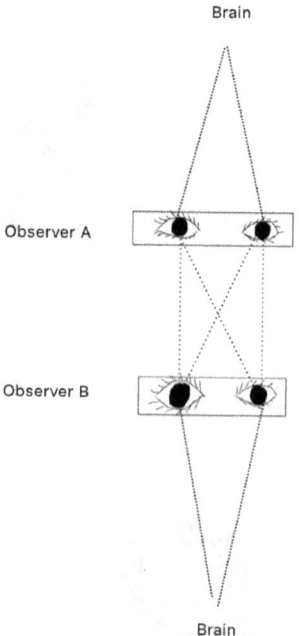

Fig: Observers looking at each other

Relativity in Clouds

(Perception, Space, Time , Emotion , Beauty)

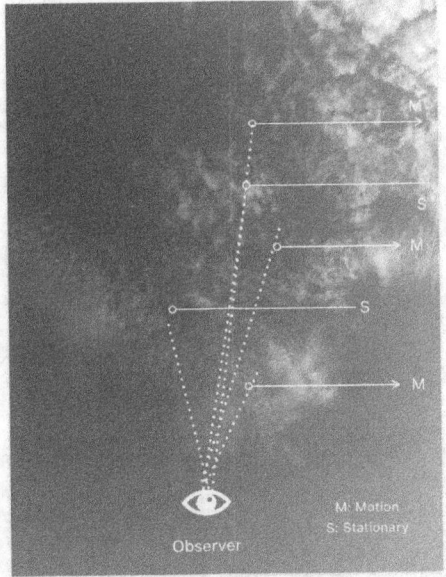

If you try to see moving clouds , you need to fixe your eyes on stationary clouds in order to experience the moving clouds. If you only perceive the moving clouds directly you would never experience them moving. You need a stationary frame of reference to measure an event and see its beauty.

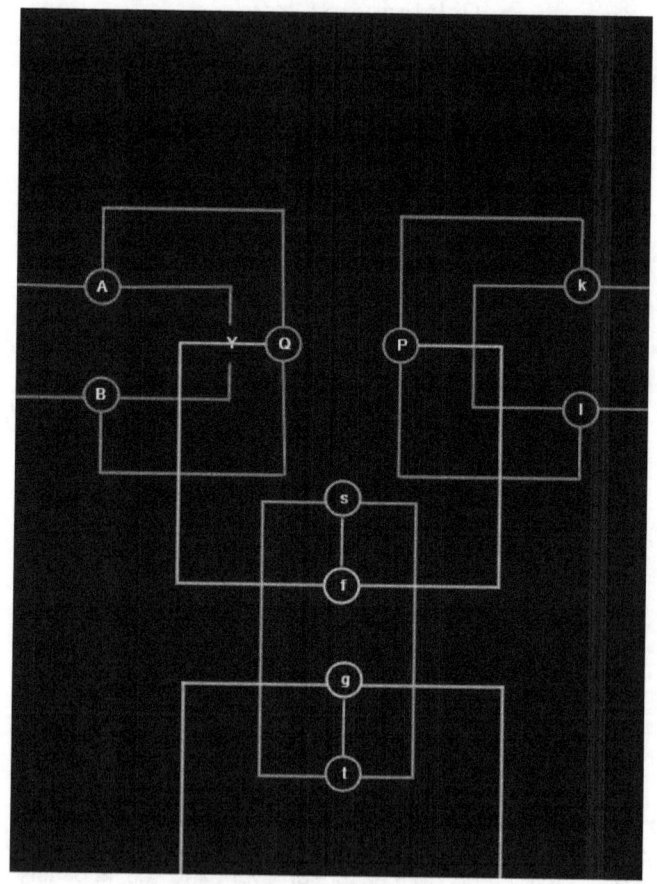

Commonalities

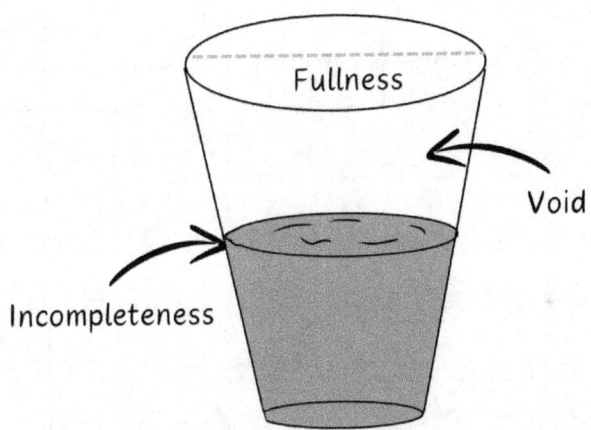

Trinity

Cosmic Algorithm

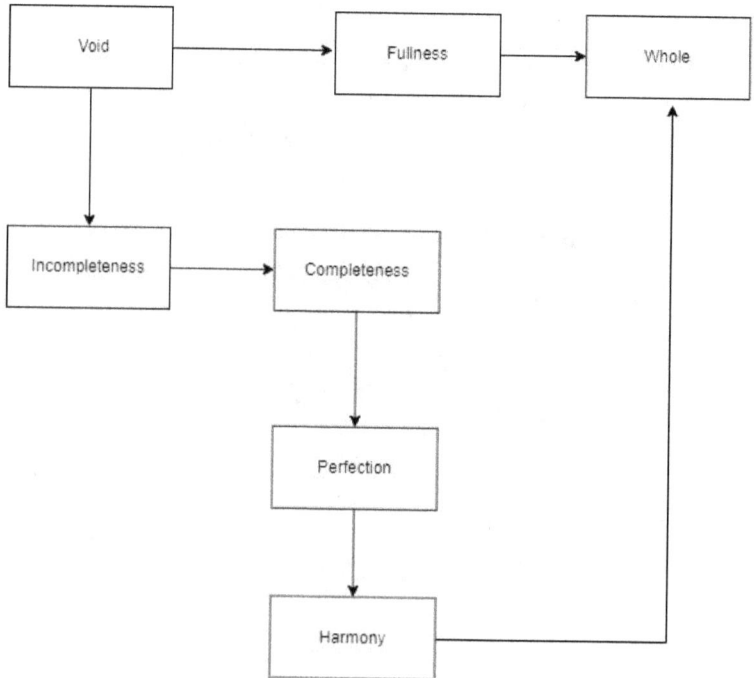

Do you see the space?

What is producing the spatial experience.

Snapshot from Philosophytube (Abigail Thorn)

www.ingramcontent.com/pod-product-compliance
Lightning Source LLC
Chambersburg PA
CBHW070128230526
45472CB00004B/1476